Renaissance Paintings

Using Perspective to Represent Three-Dimensional Objects

Janey Levy

PowerMath™

The Rosen Publishing Group's
PowerKids Press™
New York

Published in 2005 by The Rosen Publishing Group, Inc.
29 East 21st Street, New York, NY 10010

Book Design: Michael Tsanis

Photo Credits: Cover © Francis G. Mayer/Corbis; pp. 5, 19, 20 © Alinari Archives/Corbis; pp. 6, 23 © Archivo Iconographico/Corbis; pp. 8, 14, 15, 16, 17 © Arte & Immagini srl/Corbis; pp. 9 (Leon Battista Alberti), 10, 11, 12 © Corbis; pp. 9 (Filippo Brunelleschi), 30 © Bettman/Corbis; p. 13 © Owen Franken/Corbis; p. 24 © Araldo de Luca/Corbis; p. 26 (hand) © Rosen Publishing Group.

Library of Congress Cataloging-in-Publication Data

Levy, Janey.
 Renaissance paintings : using perspective to represent three-dimensional objects / Janey Levy.
 p. cm. — (PowerMath)
 Includes index.
 ISBN 1-4042-2926-4 (library binding)
 ISBN 1-4042-5115-4 (pbk.)
 6-pack ISBN 1-4042-5116-2
 1. Perspective—Juvenile literature. 2. Drawing—Technique—Juvenile literature. 3. Painting, Renaissance—Juvenile literature. I. Title. II. Series.

 NC750.L44 2005
 750'.1'8—dc22
 2004000016

Manufactured in the United States of America

Contents

What Was the Renaissance?

Between about 1300 and 1600, Europe experienced a rebirth of learning known as the Renaissance. This name comes from a French word that means "rebirth." During the Renaissance, Europeans began to study math, science, and **logic,** and to apply these studies to the world around them. Knowledge of algebra, a kind of math invented centuries earlier by Arab mathematicians, spread across Europe. Doctors and other scientists studied the human body and how it worked. Explorers, including Christopher Columbus, sailed to distant places. For the first time, Europeans learned about the vast expanse of Africa and about North and South America. The knowledge gained by explorers helped mapmakers create more accurate maps. A Polish astronomer named Nicolaus Copernicus laid the foundations of modern astronomy with his observations of the sun, moon, and planets. An Italian scientist named Galileo Galilei studied gravity.

Renaissance painters applied the same kind of **rational** approach to their own art. Just as mathematicians and scientists created theories for their work, artists created theories and rules for theirs.

Leonardo da Vinci, a famous Italian Renaissance painter, was also a scientist and inventor. This drawing by Leonardo, made around 1500, shows his design for a drilling machine. Among Leonardo's other inventions was a design for a flying machine.

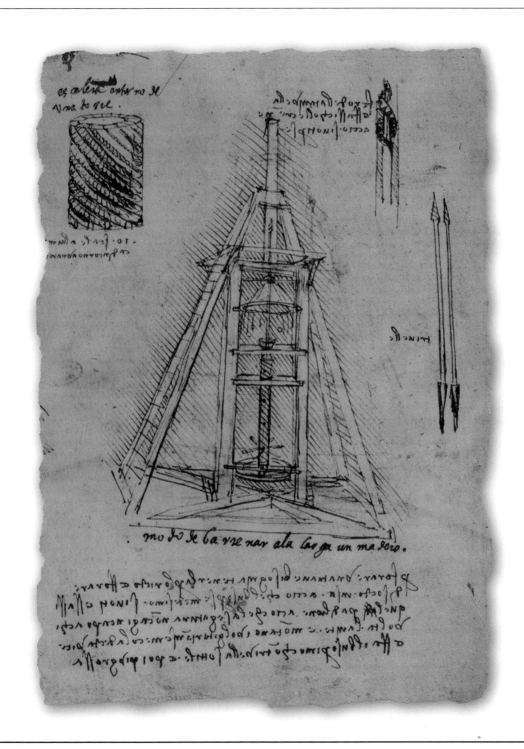

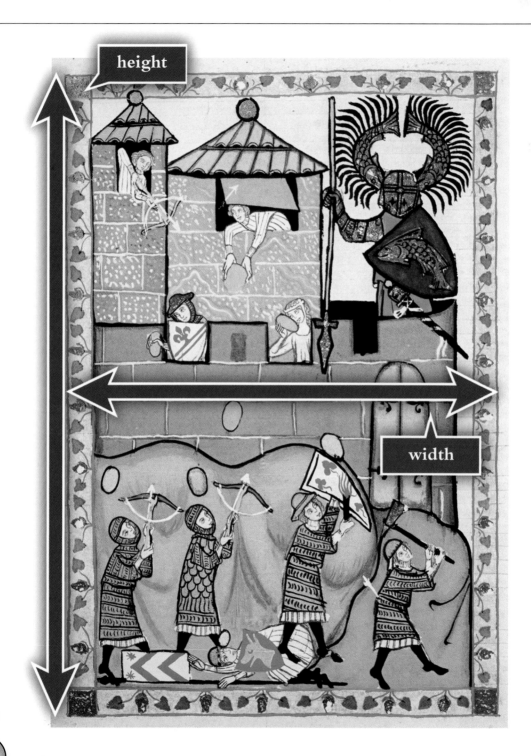

height

width

The Invention
of Perspective

Renaissance artists faced a challenge in their efforts to create paintings that would provide a convincing **illusion** of the way our world looks. Paintings are **two-dimensional**, which means that they have height and width. However, things in our world—such as houses, trees, and people—have three dimensions: height, width, and **depth**. To make a believable picture, Renaissance artists needed a set of rules that told how to make a two-dimensional representation, such as a painting, of a **three-dimensional** object. A system such as this is known as perspective. Perspective also helps artists show clearly where objects are located in space.

Let's compare two pictures to get a better idea of the effect that the use of perspective has on a painting. The first picture, shown on page 6, comes from a **manuscript** made around the beginning of the Renaissance. It shows knights attacking a castle. Only one side of the castle is visible, making it look flat. Like a piece of paper, this image has only height and width. It is more like a symbol for a castle than a convincing picture of a real, three-dimensional castle.

This picture of a battle scene at the Castle of Wartburg comes from a manuscript made in Germany in the early 1300s.

The second painting, shown below, was made more than 150 years later. It is titled *View of an Ideal City* and shows a **plaza** with a circular building in the center. Rectangular buildings of different sizes line the sides of the plaza. This painting is much different from the painting on page 6. The buildings seem real and solid. We can imagine people moving through these buildings. We can also imagine people, horses, and wagons moving through the plaza and down the streets we see between the buildings.

How did the artist achieve this? He used perspective to construct a convincing illusion of the three-dimensional world. The picture was designed by an Italian **architect** named Luciano da Laurana (loo-CHAHN-oh DAH lou-RAH-nah) and painted by an Italian artist named Piero della Francesca (PYER-oh DAYL-lah frahn-CHAY-skah).

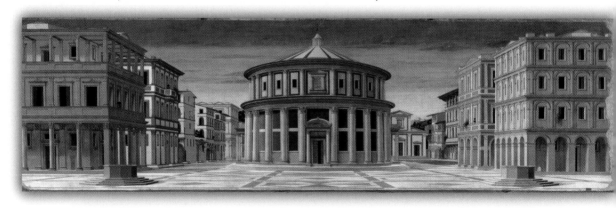

Piero della Francesca painted this picture between about 1450 and 1475.

Piero was a mathematician and painter who wrote a famous book about perspective around 1450. However, he was not the first Renaissance artist to understand perspective. An Italian architect named Filippo Brunelleschi (fee-LEEP-poh broo-nayl-LAYS-kee) figured out the mathematical rules for perspective around 1413. Brunelleschi made drawings to demonstrate perspective, but the drawings no longer exist and he never wrote down the rules. The first person to write an explanation was another Italian architect, Leon Battista Alberti (LAY-ohn ba-TEE-stah ahl-BEHR-tee). In 1435, Alberti wrote a book titled *On Painting*, in which he explained the mathematical rules for perspective.

Leon Battista Alberti　　　　**Filippo Brunelleschi**

Horizon and Vanishing Point

To understand perspective, imagine that you are standing in the middle of a road, looking straight down it. You know that the sides of the road are **parallel**, which means that they are always the same distance apart. However, as you look straight down the road, the sides seem to get closer and closer to each other—like the sloping sides of a triangle—until they seem to meet in a point on the **horizon**. This point, where the separateness of the lines disappears, is called the vanishing point.

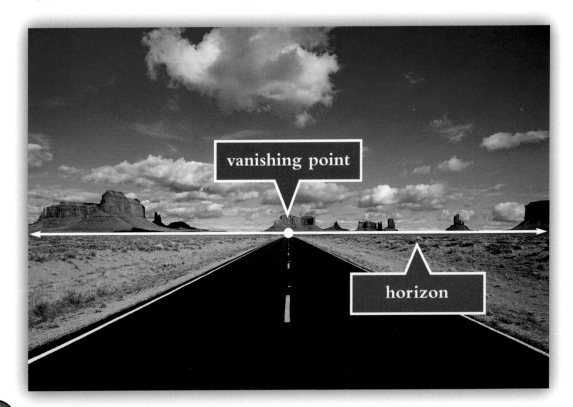

In the case of the road, we're talking about a simple situation with just two parallel lines that meet at the vanishing point. What happens if there are a lot of parallel lines? Let's look at an example. Imagine that you're standing in a field with many rows of crops planted parallel to each other. Just as we saw happen with the sides of the road, the rows of crops seem to get closer and closer to each other until they meet at the vanishing point.

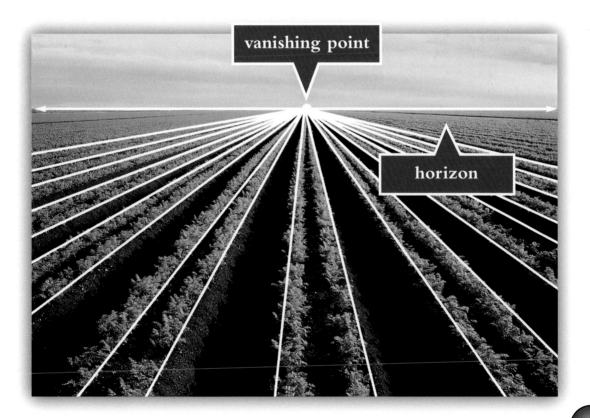

Now look at this photograph of a pier. The **vertical** posts along the sides are evenly spaced, but they seem to get closer together as they get nearer to the vanishing point. Also notice that while the posts are all the same size, they seem to get smaller as they near the vanishing point. In the same way, people, buildings, and any other objects in the **foreground** would appear larger than objects nearer to the vanishing point.

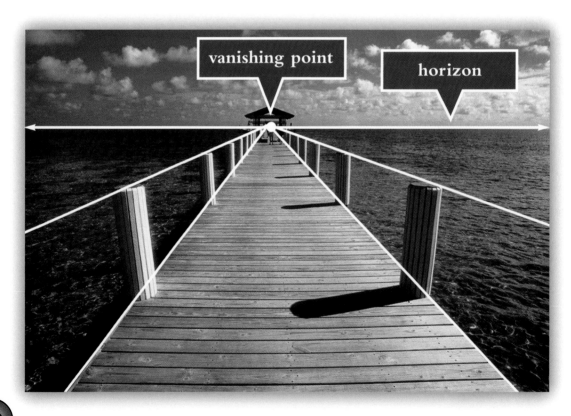

Finally, imagine that you are standing on a sidewalk looking down a row of structures, such as the telephone booths in this photograph. You know that the tops of the booths are parallel to the bottoms. However, if you draw lines along the tops and bottoms and extend them beyond the booths, you find the lines meet at the vanishing point, just like the sides of the road or the rows of crops. Following the rules of perspective, the parallel lines in a scene will meet at the vanishing point.

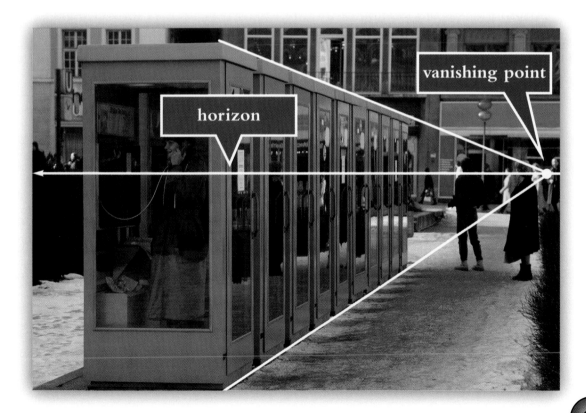

Analyzing Perspective
in Renaissance Paintings

Let's use what we've learned about perspective to **analyze** how some Renaissance artists applied these mathematical rules to their art. We can go back to Piero's *View of an Ideal City.*

Look at the lines formed by the stone patterns of the plaza. They **converge** on a vanishing point, which is located in the center of the doorway in the round building at the middle of the plaza. This imitates what we saw happening to the rows of crops shown in the earlier photograph and creates the illusion that we are looking at a real plaza whose stones form a pattern of parallel lines.

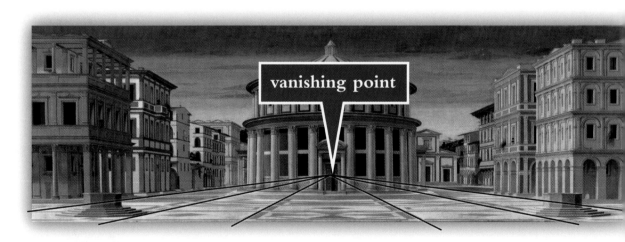

vanishing point

The buildings around the plaza resemble the telephone booths shown in the photograph on page 13. If we extend the lines formed by the roofs, bases, and rows of stone in the buildings, we find that they also converge on the vanishing point.

Remember the earlier photographs of the pier and the telephone booths, and notice how perspective affects the heights of the buildings. The first two buildings on each side are the same height, but the second building appears smaller than the first building. This is because the second building is farther away.

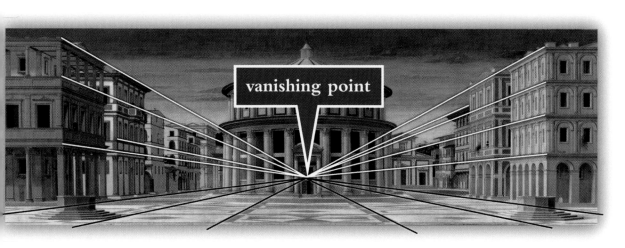

vanishing point

You've probably noticed that we've talked about the parallel lines and the vanishing point in this painting but haven't said anything yet about the horizon. That's because we can't see the actual horizon in this painting. The buildings of the plaza block our view of it. However, that doesn't mean the horizon is not important in this picture. It still plays a necessary part in the **composition.** Before Piero could decide where to put the buildings and how to paint them according to the rules of perspective, he had to decide where to place the horizon. We can determine where the horizon is by using the vanishing point, which we know is located on the horizon.

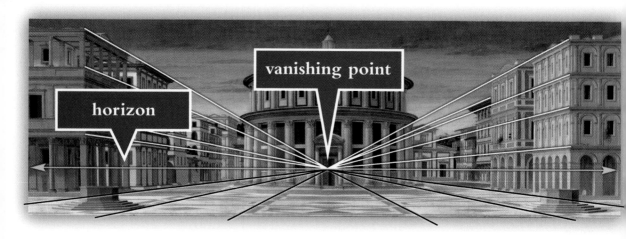

The horizon played an important role in Renaissance paintings. Artists often used the horizon to indicate to the viewer where they were positioned in space in relation to the scene in the painting. The viewer was supposed to pretend that the horizon was at eye level. In *View of an Ideal City*, the horizon runs through the center of the doorway in the round building. That's the eye level a person would have if they were standing in the plaza facing the doorway. This puts the viewer right in the space of the painting. They can imagine walking across the plaza and into the round building, then perhaps coming out of the building and exploring some of the side streets.

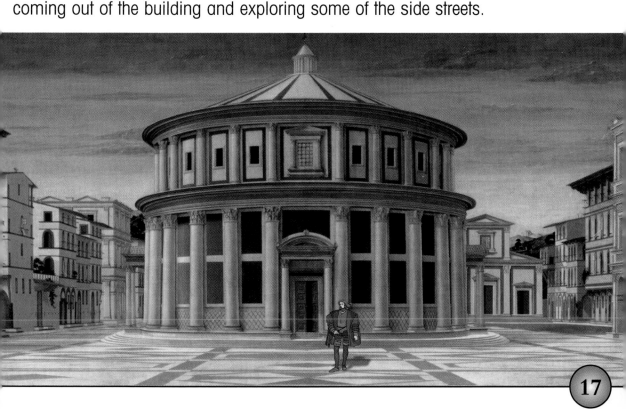

It is easy to study the perspective in *View of an Ideal City.* There are no people or other objects that might make it difficult to trace to the vanishing point all those lines that would be parallel in our three-dimensional world. Now let's try applying the same procedure to a painting that includes many people. The painting we'll examine is one of the most famous paintings of the Renaissance. It was painted by Raphael (RAF-ee-uhl), one of the most famous Italian artists of the Renaissance. The painting, titled *The School of Athens,* was created around 1510. It shows an imaginary scene of the great philosophers, scientists, and mathematicians of ancient Greece. They have gathered in a vast hall to meet, discuss their ideas, and try to solve difficult problems. In the center are two important Greek philosophers—Plato (PLAYT-oh), on the left, and Aristotle (AR-uh-staht-uhl), on the right. A little to the left of Plato, we see a bald man counting off ideas on his fingers. This is the philosopher Socrates (SAHK-ruh-teez). In the lower left corner, kneeling and writing, is the mathematician Pythagoras (puh-THAG-uh-ruhs). In the lower right corner, we see the mathematician Euclid (YOU-kluhd), bending over to write on a tablet on the floor.

Raphael painted this picture on a wall. You can see a door in the lower left corner. The top of the painting is rounded because the ceiling in the room is curved.

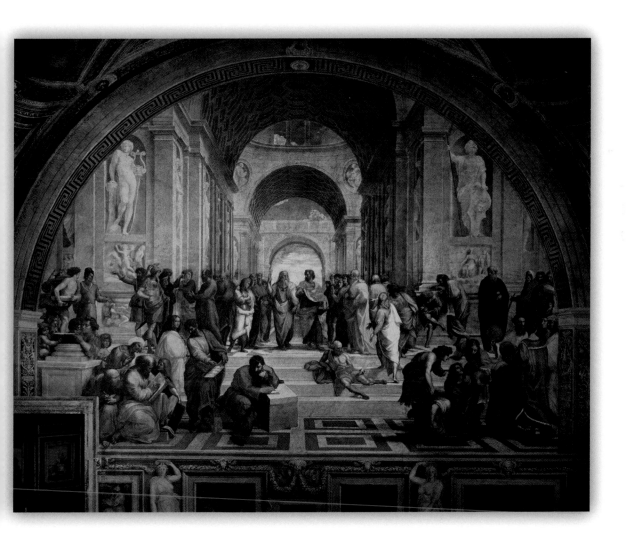

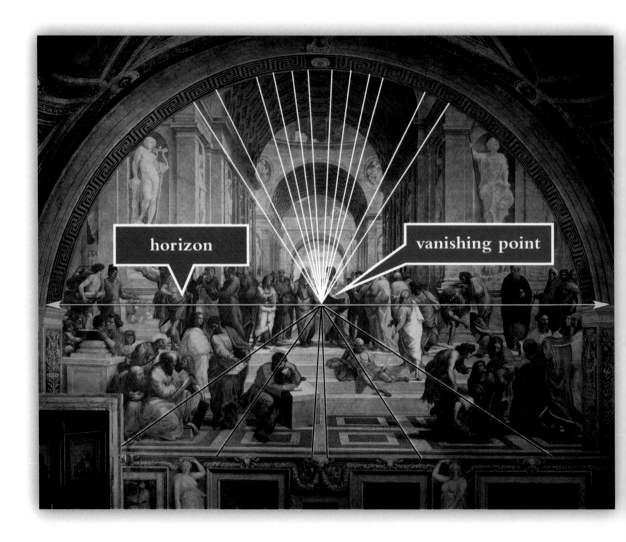

Like the plaza in Piero's painting, the floor in Raphael's painting has colored stones that form patterns with parallel lines. These lead us to the vanishing point, which is centered between Plato and Aristotle. The parallel lines we can trace in the walls and arched ceiling lead to this vanishing point as well. Also notice that perspective makes the second ceiling arch appear smaller than the first arch—even though they would be the same height in the real world—just as the second building on each side of Piero's plaza appears smaller than the first. This seeming difference in size also applies to the figures. The figures in the foreground appear taller than those farther away.

Although the parallel lines of perspective in Raphael's painting are not as obvious as those in Piero's painting, they are just as carefully placed. They create an illusion of space that seems so real that we can imagine walking around in it. We can also tell exactly where each of the figures is in relation to the other figures.

Raphael also used perspective to focus the viewer's attention on the most important figures in the painting. Since the parallel lines lead to the vanishing point between Plato and Aristotle, the viewer's attention is immediately led directly to those two people.

The ability to use perspective well was so highly valued that some artists made paintings just to show off their perspective skills. That is what a Dutch painter named Jan Vredeman de Vries (YAHN VRAY-duh-muhn DUH VREEZ) did in this painting made in the late 1500s. The painting shows a covered walkway attached to a group of buildings. The walkway fills most of the picture. Buildings are visible behind it. There is a fountain near the lower right corner, and we can see a garden with trees just behind the walkway above the fountain. A few people are positioned around the walkway, including a man with a dog on the left, near the bottom edge of the painting. A cage with a parrot occupies the lower left corner. However, the scene doesn't tell a story. The figures and other features are simply used to decorate the real subject of the painting, which is a convincing illusion of three-dimensional space created by perspective.

Like Leon Battista Alberti and Piero della Francesca, Jan Vredeman de Vries wrote a book on perspective. His book, which consisted mostly of pictures, was first published in 1604.

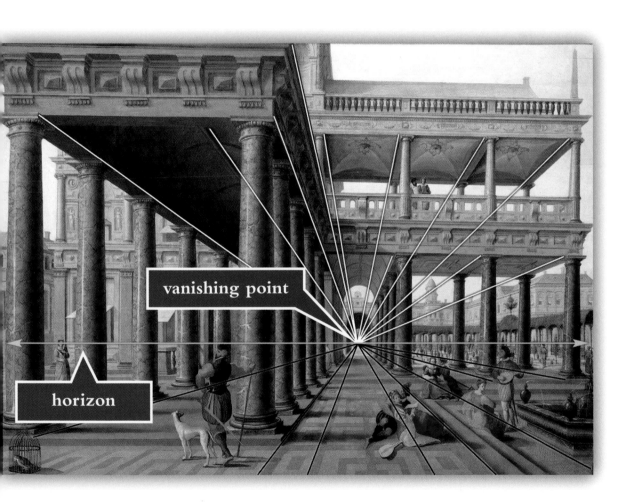

vanishing point

horizon

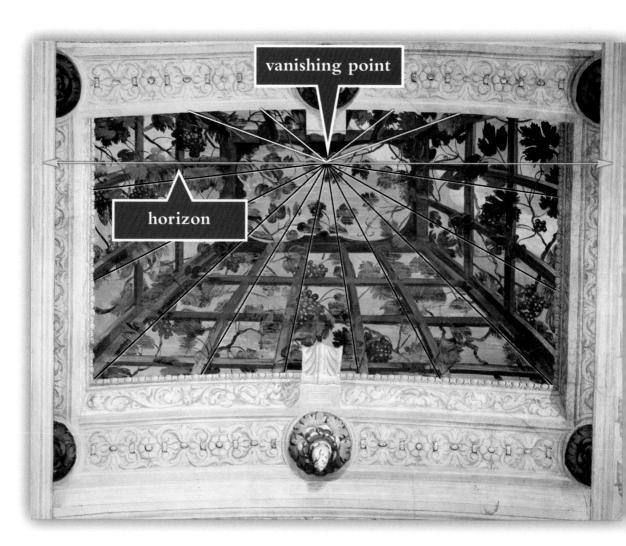

Fooling the Eye

Many Renaissance painters used perspective in wall and ceiling paintings to fool viewers into thinking that they were looking into a space beyond the wall or ceiling rather than at a painted surface. This ceiling painting, created by an Italian painter named Paolo Veronese (POW-loh vay-roh-NAY-zay) in the 1560s, shows grapevines growing on a **lattice**. Veronese used perspective to create the illusion that the viewer is looking through an opening or window in the ceiling at a lattice on the roof. The sides of the imaginary lattice are built around the sides of the "opening" and rise up toward the blue sky.

In a painting like this, the horizon is simply the imaginary line that is at eye level for the viewer. You might have expected that Veronese would place the horizon through the middle of the picture, to make it appear that the viewer is standing directly under the "opening" and looking straight up. However, he placed it closer to one side. This makes it seem to the viewer that they are standing to one side of the opening while looking up.

Paolo Veronese did many wall and ceiling paintings in this country house near Venice. The house was built around 1550 for a wealthy Italian family.

You're the Artist

Imagine that you're a Renaissance painter. You've been hired by an Italian duke to paint a city scene on one of the walls in his palace. Before you begin the painting, you must first do several drawings to work out the perspective for the scene. Let's do a drawing step-by-step to show how you would go about this.

We'll start with a simple drawing of a pair of buildings. The first step is to position the horizon and vanishing point. Use a ruler to help you draw a straight line for the horizon. Measure with the ruler to place the vanishing point in the middle.

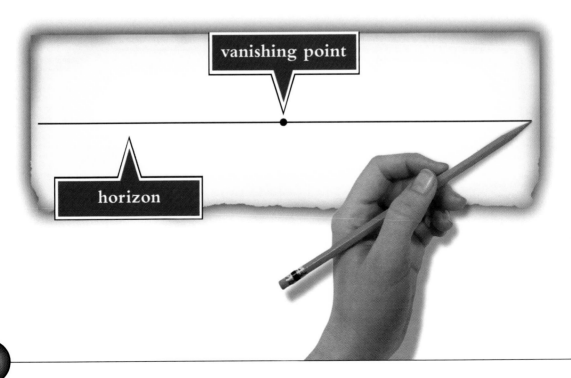

vanishing point

horizon

Next, draw a square for the front of one building and a rectangle for the front of the second building. Use your ruler to help you make your lines straight.

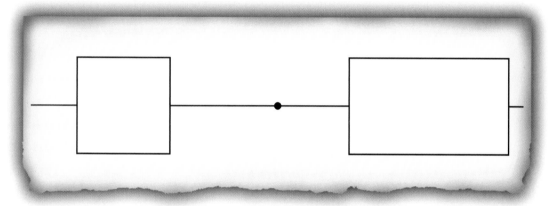

Next, draw the sides of the buildings. To do this, you must first draw lines to the vanishing point from the corners of the square and rectangle that are nearest to the vanishing point.

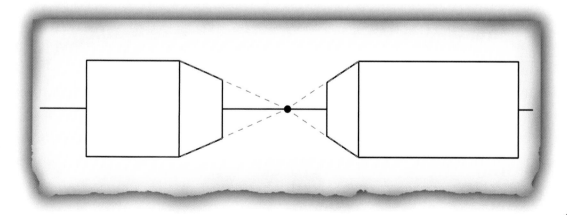

Now add doors and windows to each building. Remember to draw lines converging on the vanishing point to help you place the top and bottom edges of the windows on the sides of the buildings.

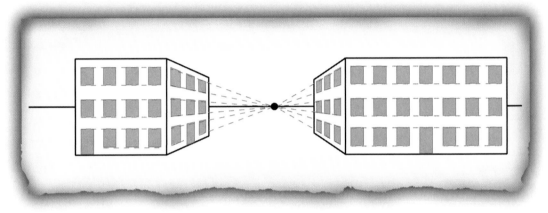

Next, add a plaza with patterns of colored stone similar to the plaza in *View of an Ideal City* or to the floor in Raphael's *School of Athens*.

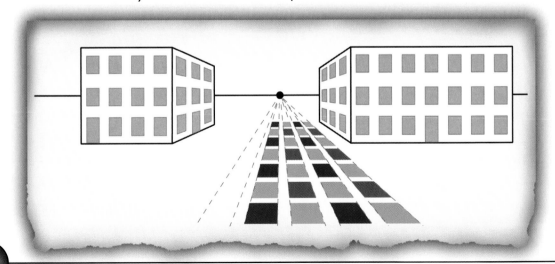

Finally, add some people to the plaza. Remember that according to the rules of perspective, people in the foreground will appear larger than people in the distance.

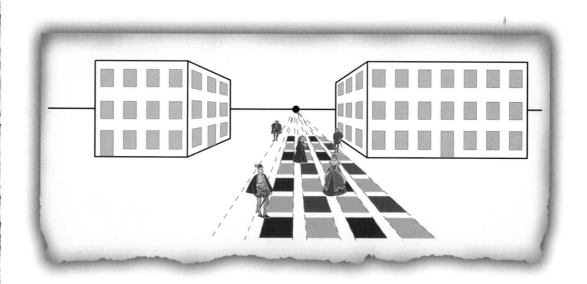

Congratulations! You've made a drawing using Renaissance perspective. After the duke approves your drawing, you'll be ready to begin painting the scene on the duke's palace wall.

For this introduction to perspective, we kept the drawing fairly simple. Except for the figures we added at the end, everything in our picture was a simple geometric shape with four straight sides. Renaissance painters often faced much more difficult challenges. For example, they often had to show buildings with arches, curved ceilings, many columns, or many decorative features. Creating the correct perspective framework for such buildings required advanced math skills, as you can see in the picture shown here. Did you ever imagine that artists would need such math skills? What other examples can you find of perspective in art?

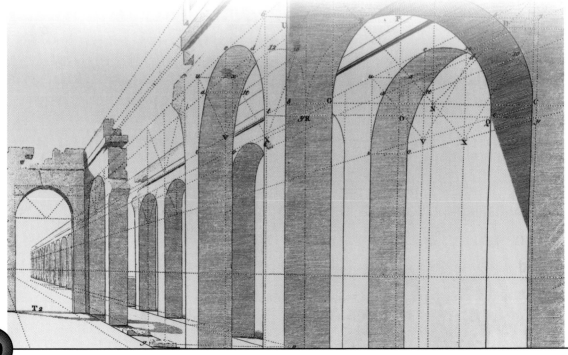

Glossary

analyze (A-nuhl-ize) To study something in a scientific, methodical way.

architect (AR-kuh-tekt) Someone who designs buildings.

composition (kahm-puh-ZIH-shun) The arrangement of objects and figures in a painting.

converge (kuhn-VUHRJ) To come closer and closer together.

depth (DEPTH) The distance from the front of an object to the back.

foreground (FOHR-ground) The part of a scene that is closest to the viewer.

horizon (huh-RY-zuhn) The imaginary line where Earth and sky meet.

illusion (ih-LOO-zhun) The appearance of having qualities not actually possessed.

lattice (LA-tuhs) A framework of crossed wooden strips that provides support for growing plants.

logic (LAH-jihk) A science that deals with the rules of sound thinking and reasoning.

manuscript (MAN-yuh-skript) A book written entirely by hand.

parallel (PAIR-uh-lel) Extending in the same direction, always the same distance apart, and never meeting.

plaza (PLA-zuh) A public square in a city or town.

rational (RA-shuh-nuhl) Based on reason.

three-dimensional (three–duh-MEN-shuh-nuhl) Having height, width, and depth.

two-dimensional (too–duh-MEN-shuh-nuhl) Having height and width.

vertical (VUHR-tih-kuhl) Located at right angles to the plane of a supporting surface.

Index